COPYRIGHT © 2017

ALL RIGHTS RESERVED. NO PART OF THIS PUBLICATION MAY BE REPRODUCED, DISTRIBUTED, OR TRANSMITTED IN ANY FORM OR BY ANY MEANS, INCLUDING PHOTOCOPYING, RECORDING, OR OTHER ELECTRONIC OR MECHANICAL METHODS, WITHOUT THE PRIOR WRITTEN PERMISSION OF THE PUBLISHER, EXCEPT IN THE CASE OF BRIEF QUOTATIONS EMBODIED IN CRITICAL REVIEWS AND CERTAIN OTHER NONCOMMERCIAL USES PERMITTED BY COPYRIGHT LAW.

Coloring Books For Toddlers
Shapes, Numbers

This Book
Belongs To

TRIANGLE

SQUARE

DIAMOND

OCTAGON

RECTANGLE

ELLIPSE

TRAPEZOID

HEXAGON

RIGHT TRIANGLE

PENTAGON

HEPTAGON

CROSS

KITE

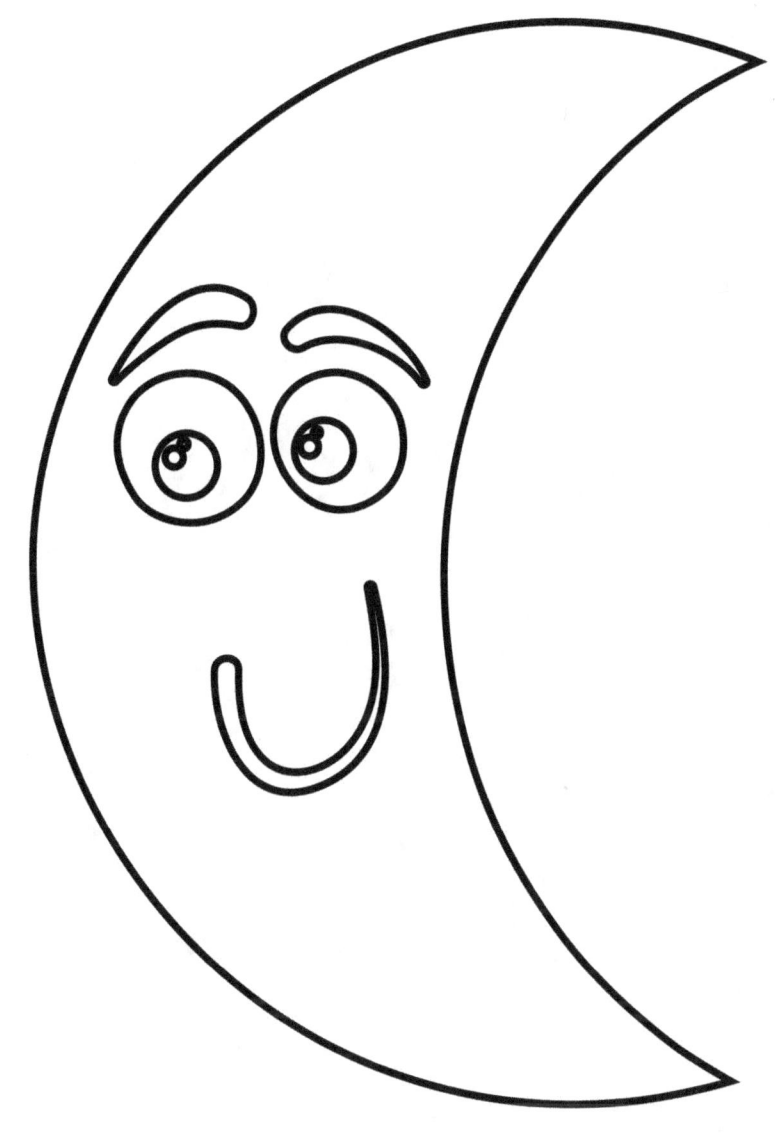

CRESCENT

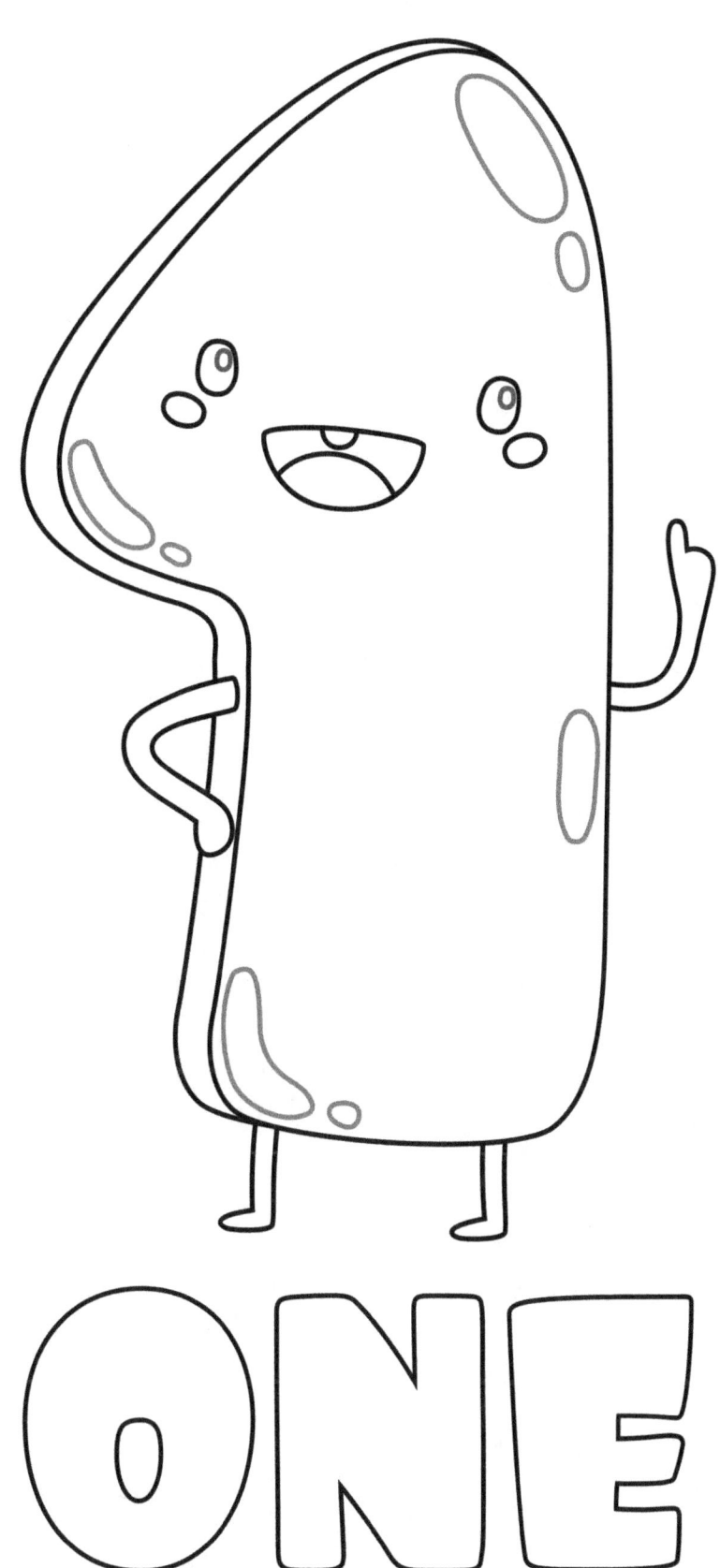

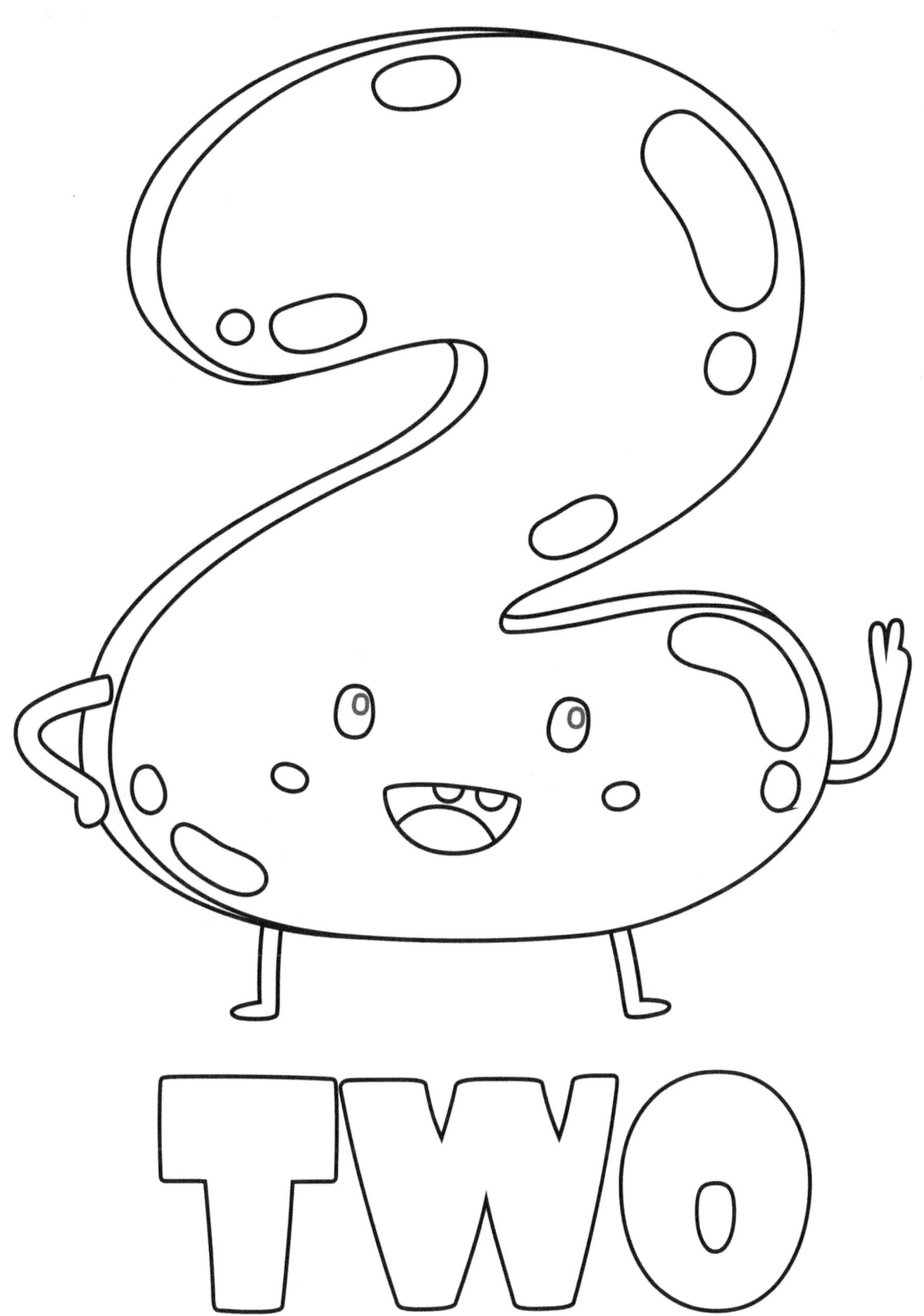

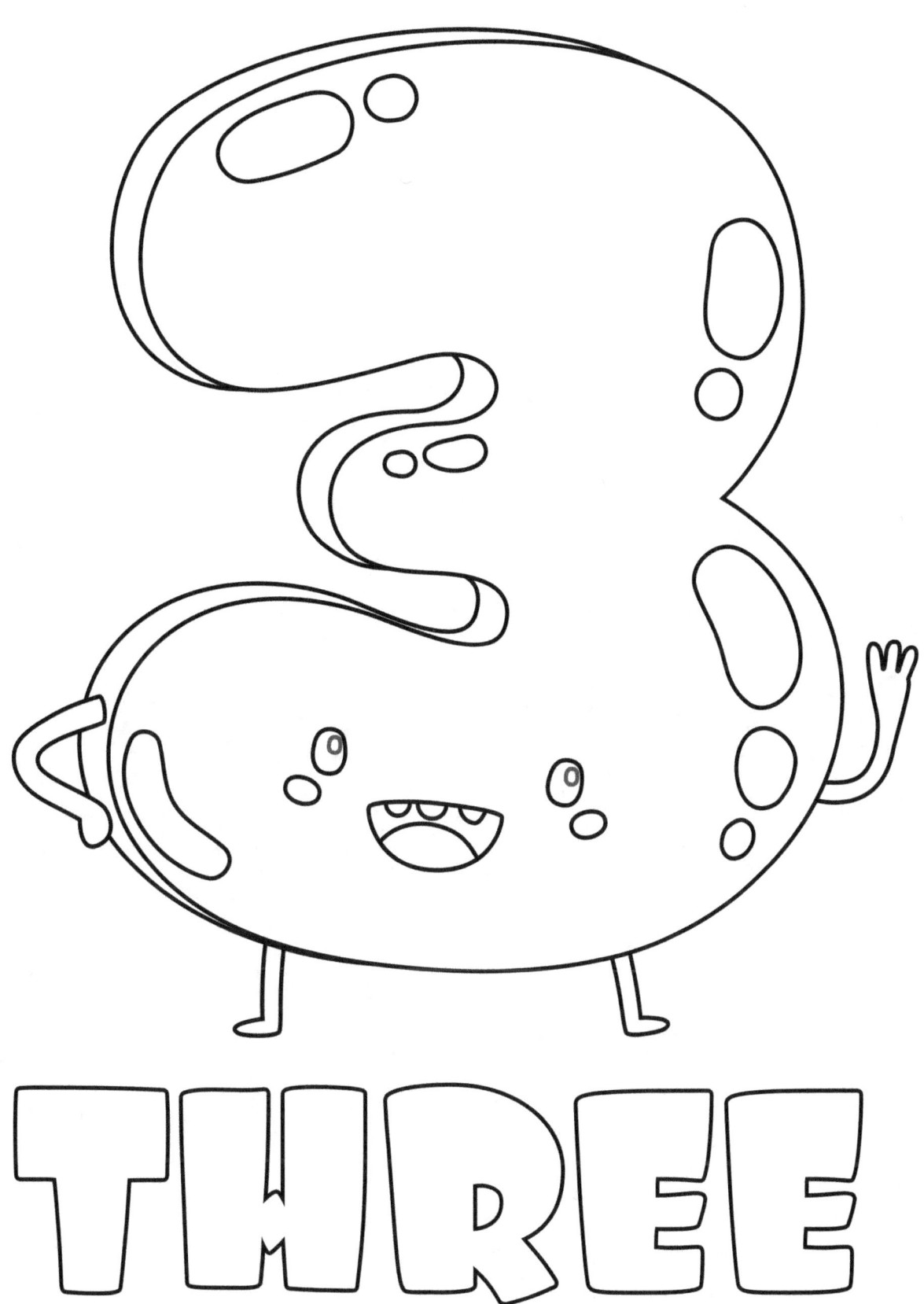

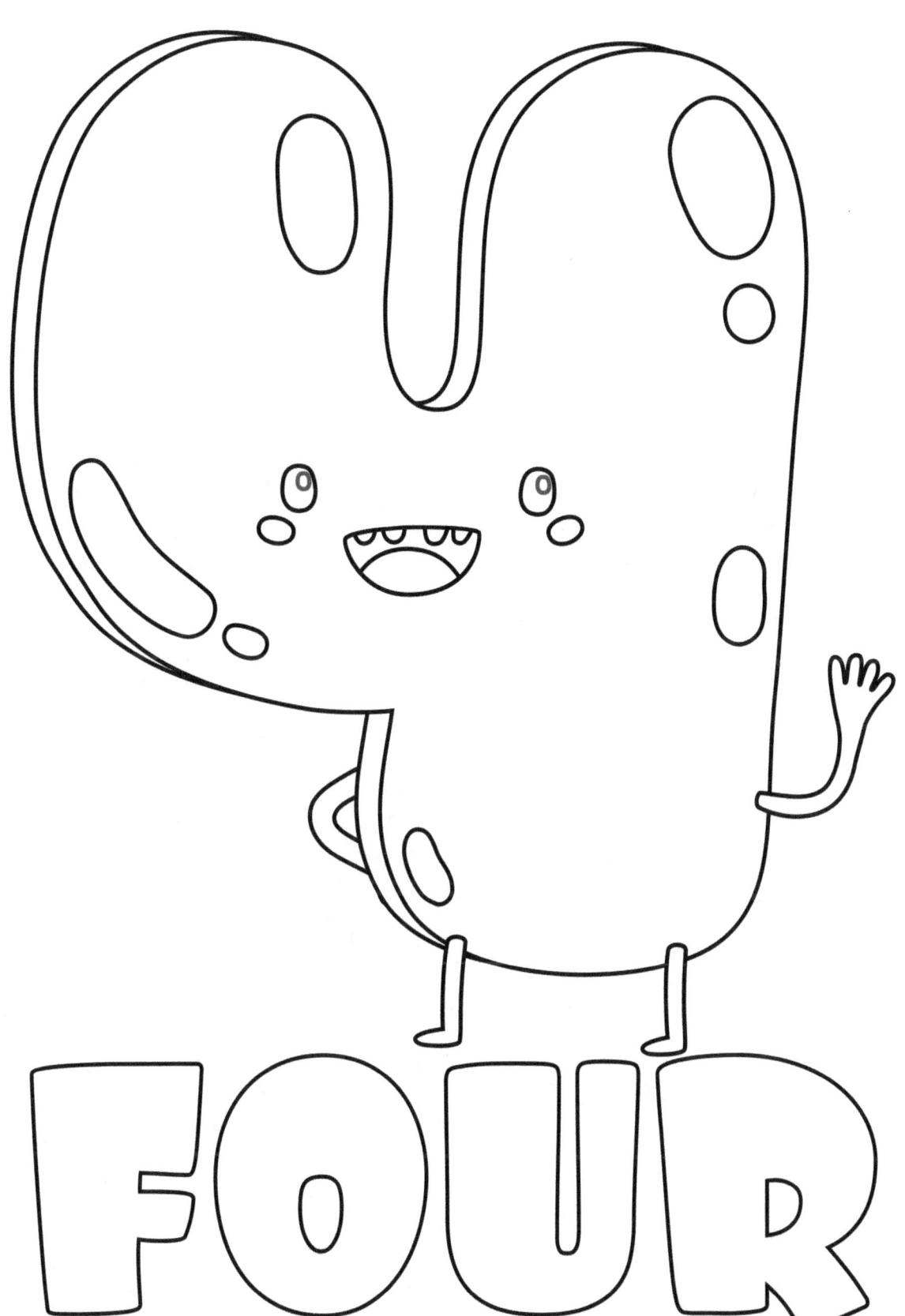

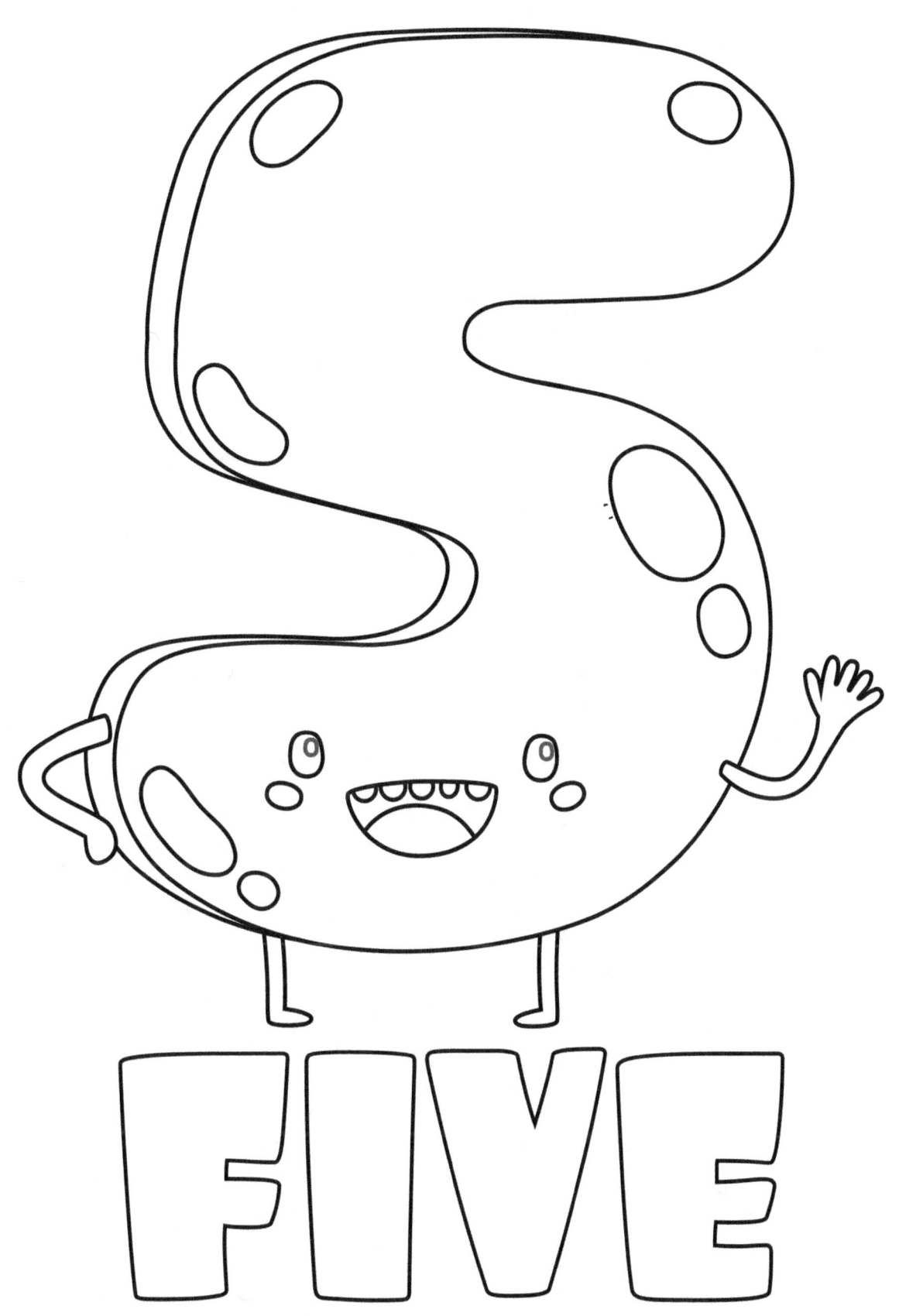

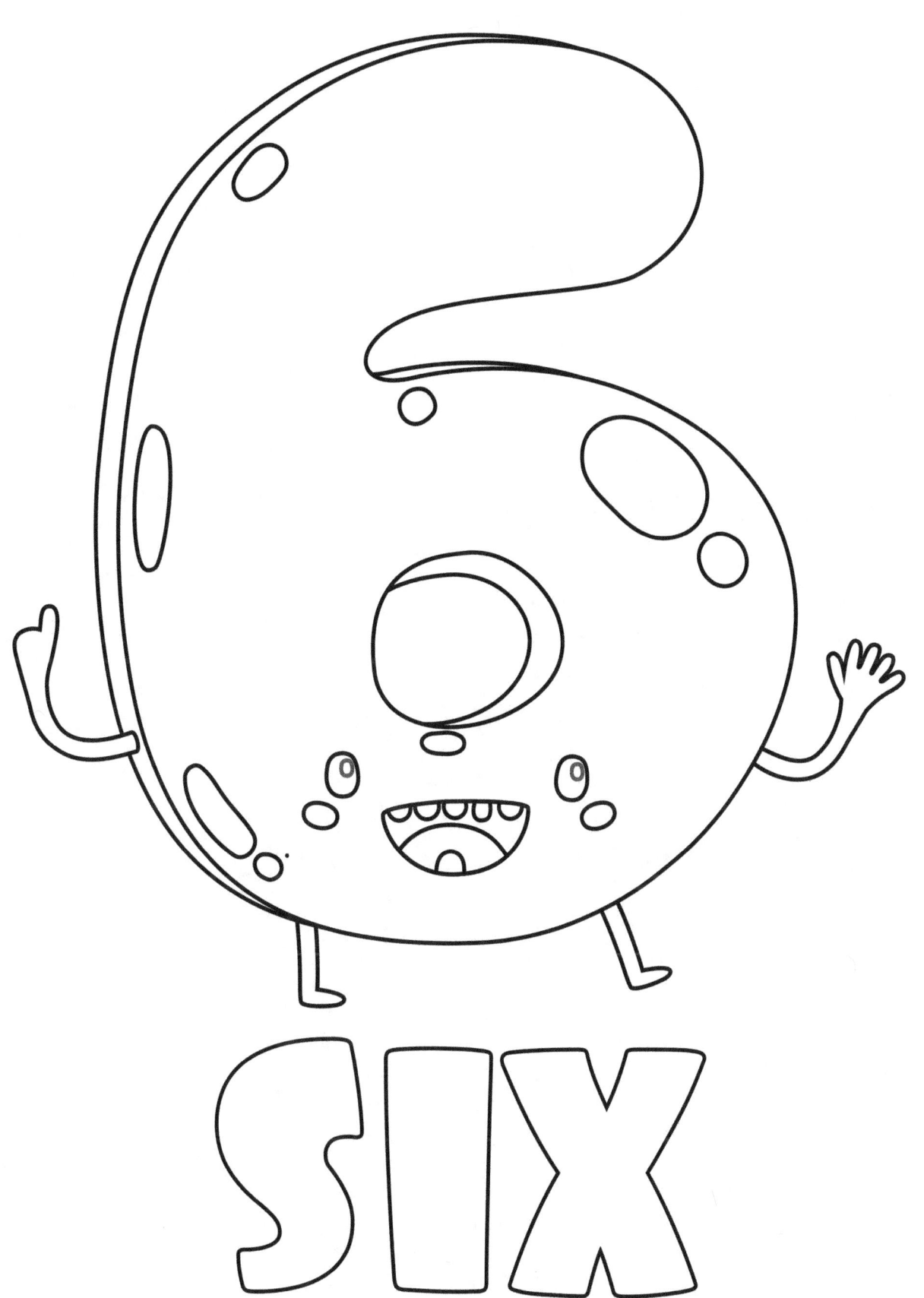

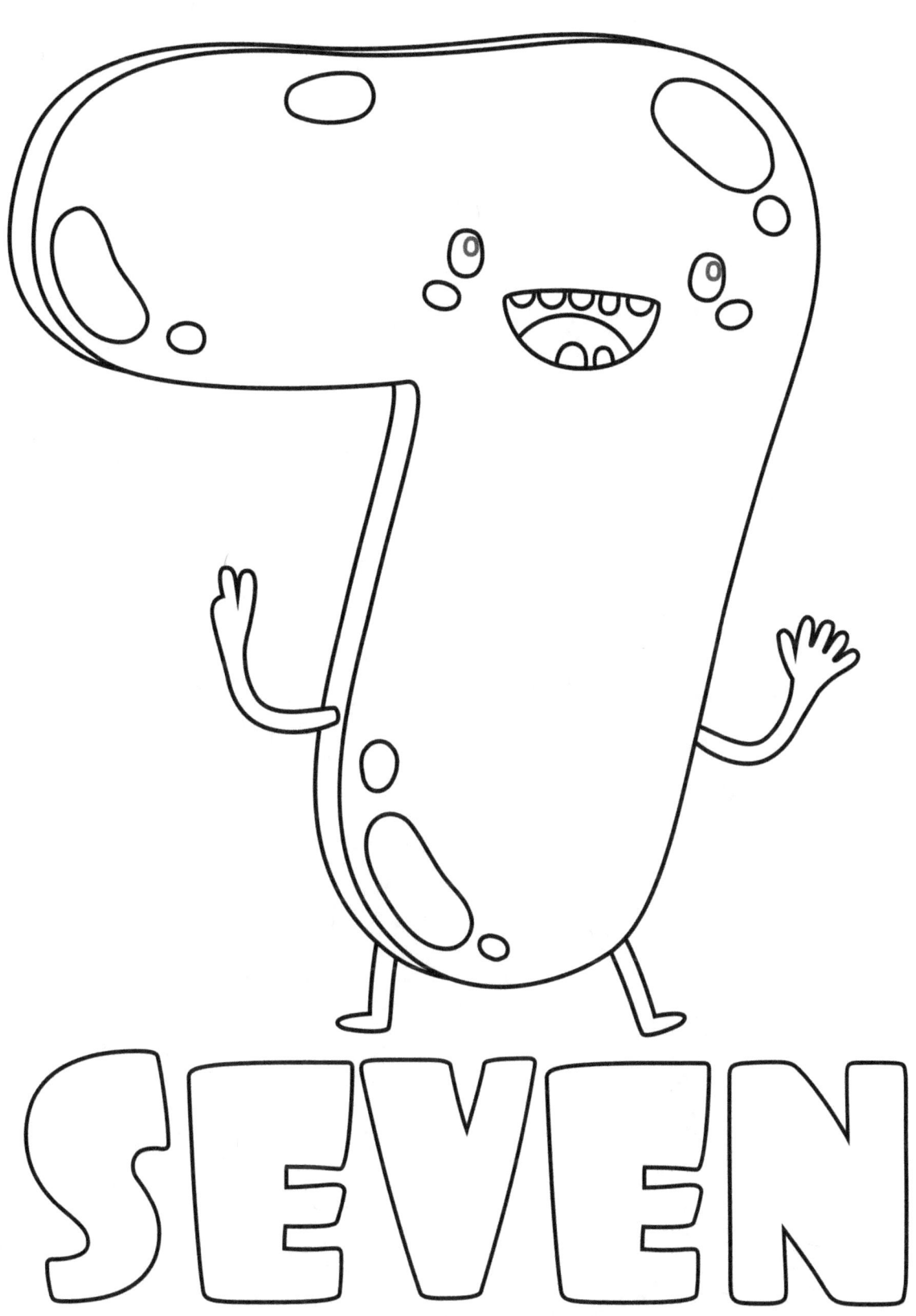

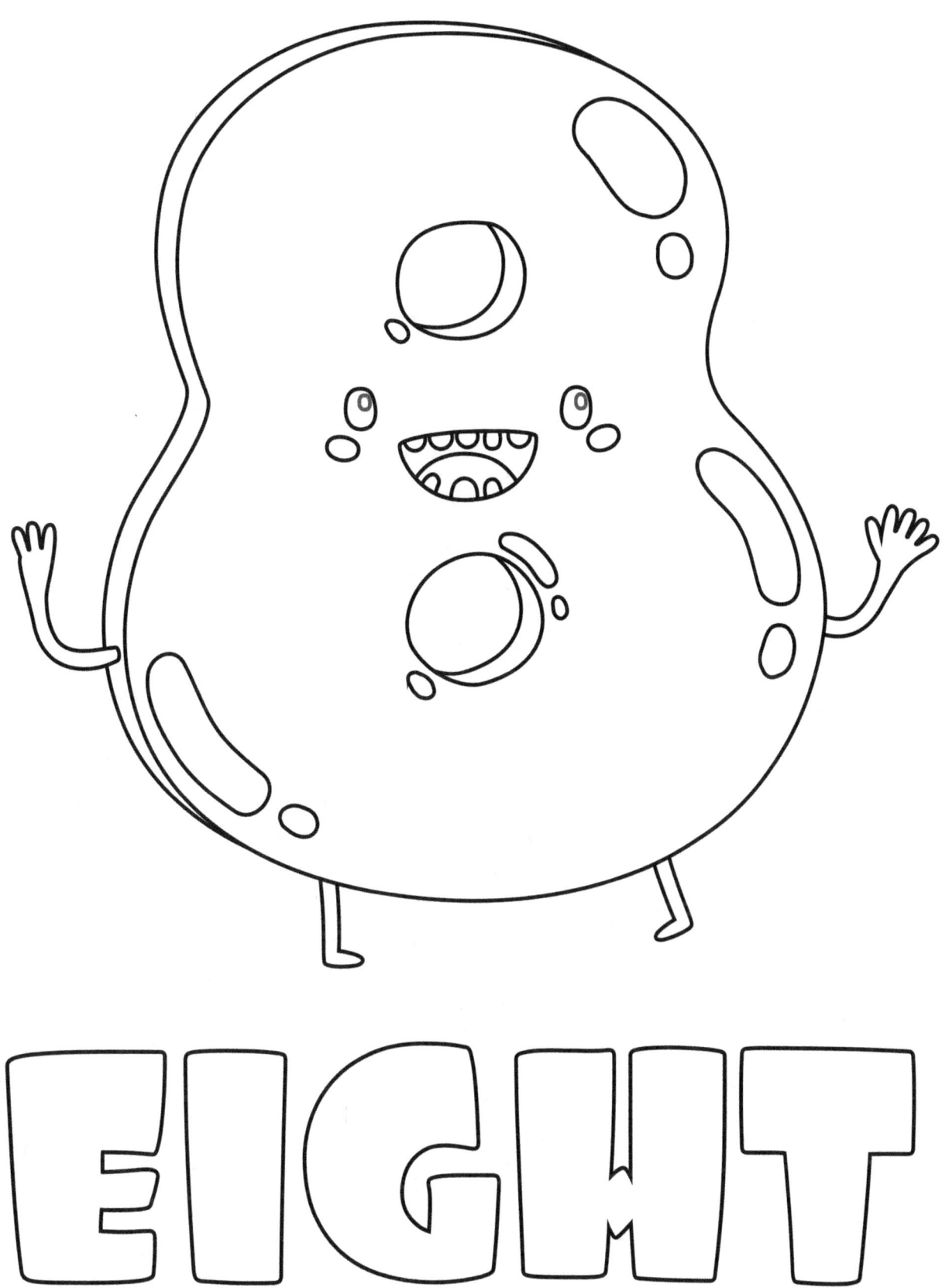

EIGHT

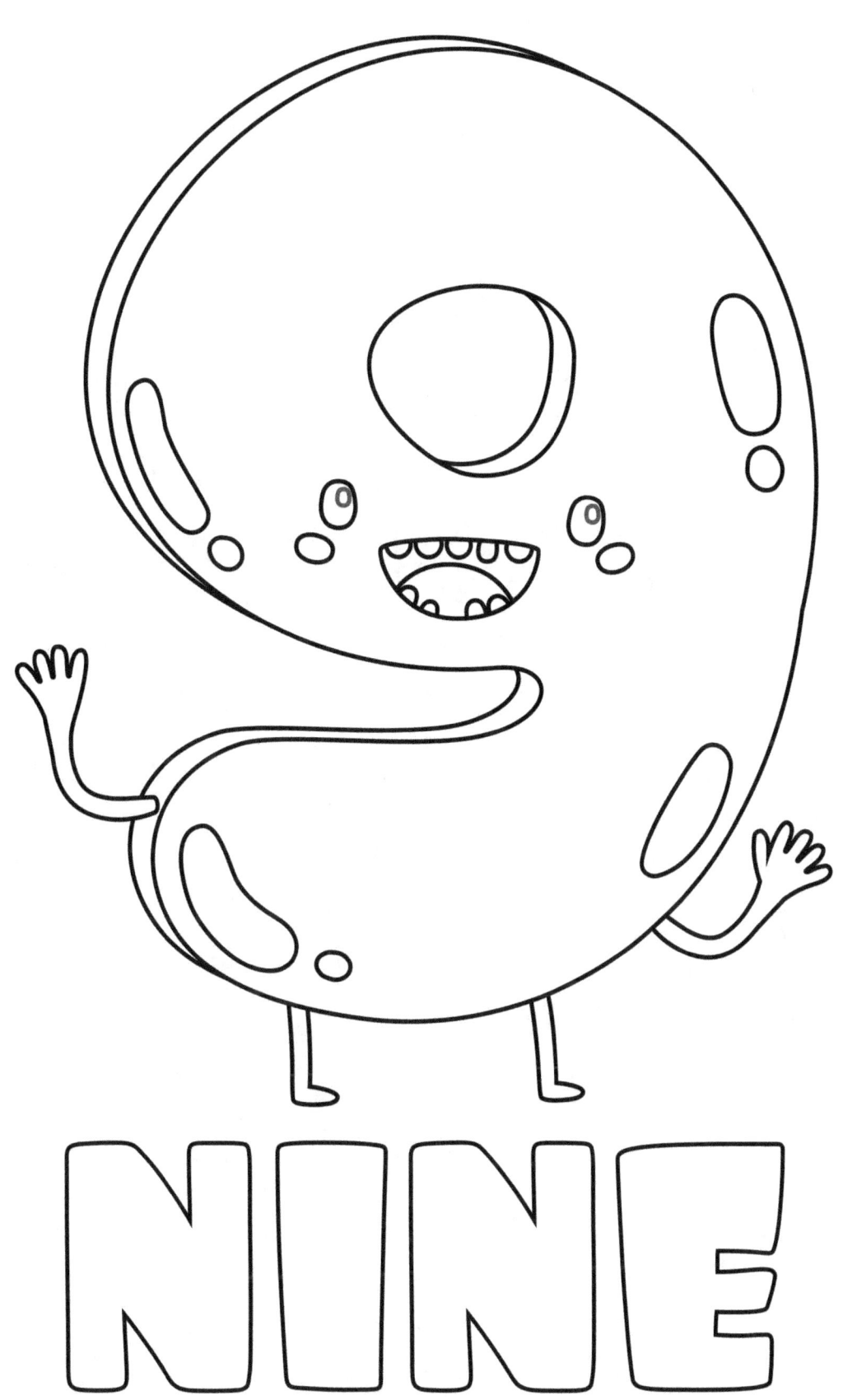

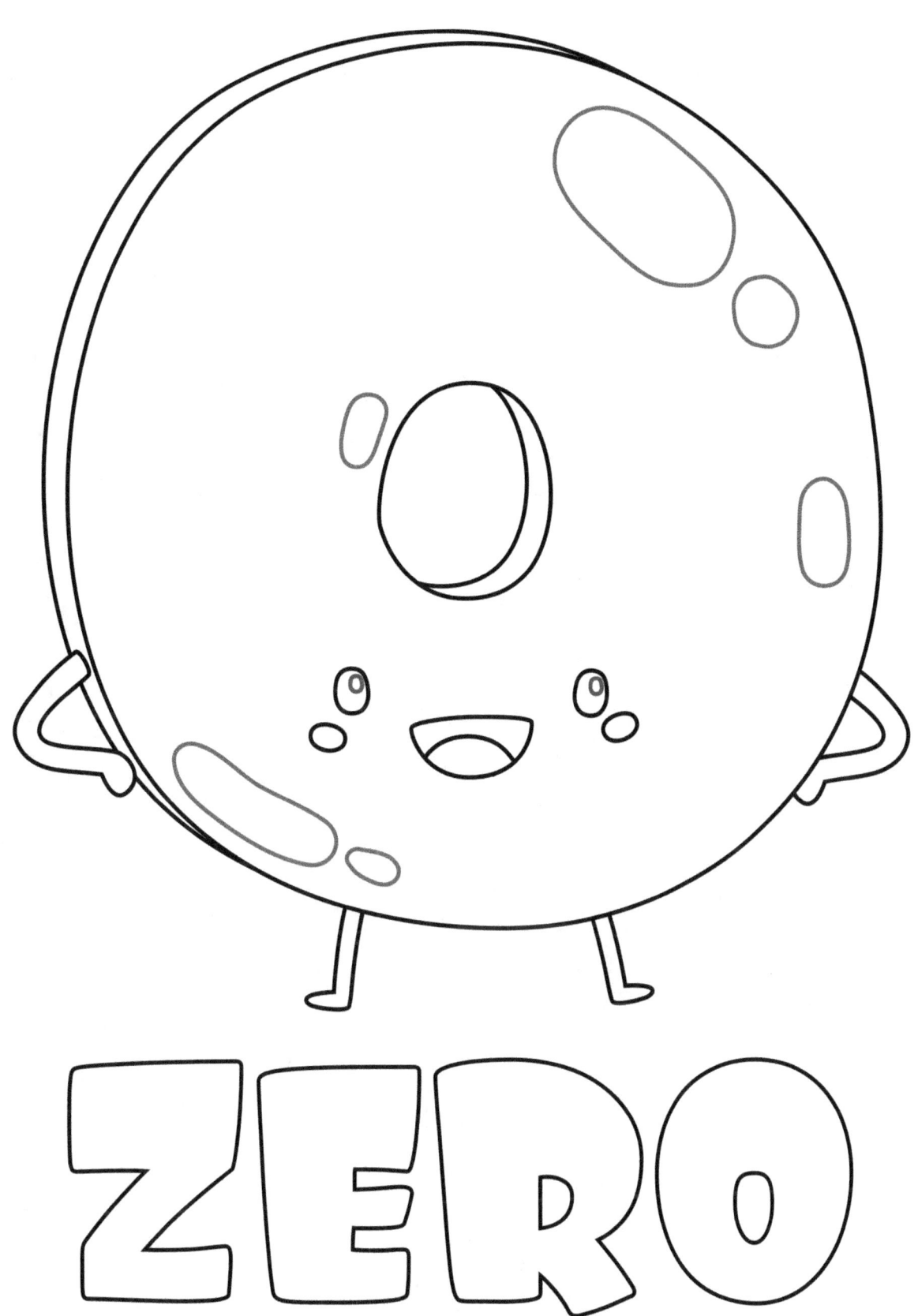